Dragons in Flight

A How to Draw Activity Book

Activibooks for Kids

All Rights reserved. No part of this book may be reproduced or used in any way or form or by any means whether electronic or mechanical, this means that you cannot record or photocopy any material ideas or tips that are provided in this book.

Copyright 2016

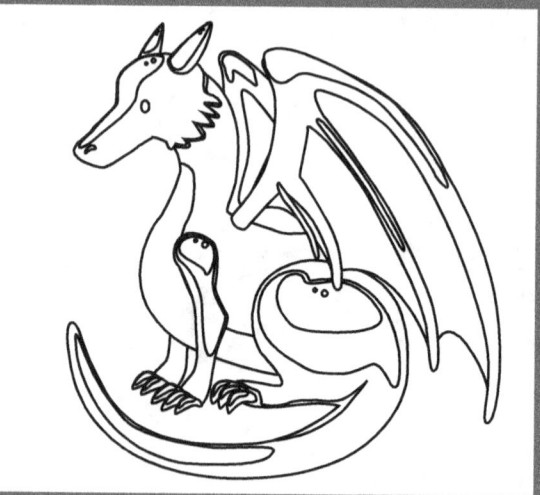

DRAW
THE
IMAGE

This is a Bleed Through Page If You Are Using a Coloring Marker or Pen!
Find Other Great Titles By searching for Activibooks For Kids on Your Favorite Book Retailer
Amazon.Com | Barnes & Noble (BN.Com) | Books A Million (BAM.Com)

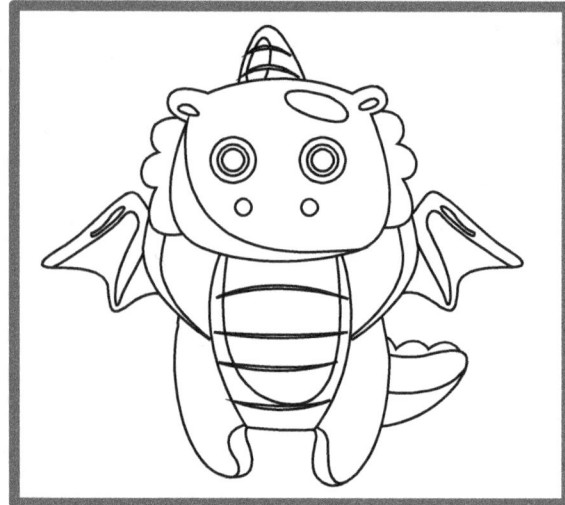

DRAW
THE
IMAGE

This is a Bleed Through Page If You Are Using a Coloring Marker or Pen!
Find Other Great Titles By searching for Activibooks For Kids on Your Favorite Book Retailer
Amazon.Com | Barnes & Noble (BN.Com) | Books A Million (BAM.Com)

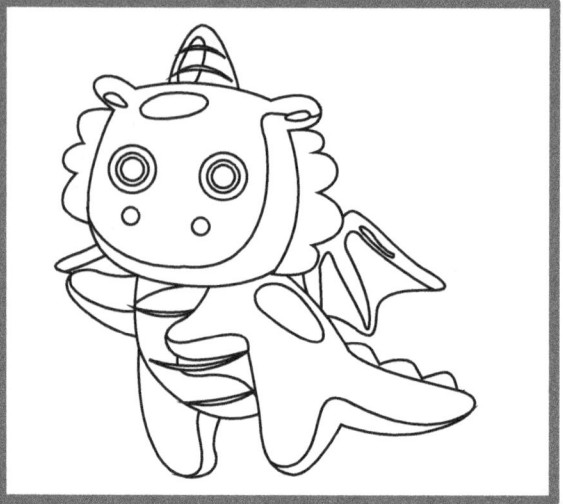

DRAW
THE
IMAGE

This is a Bleed Through Page If You Are Using a Coloring Marker or Pen!
Find Other Great Titles By searching for Activibooks For Kids on Your Favorite Book Retailer
Amazon.Com | Barnes & Noble (BN.Com) | Books A Million (BAM.Com)

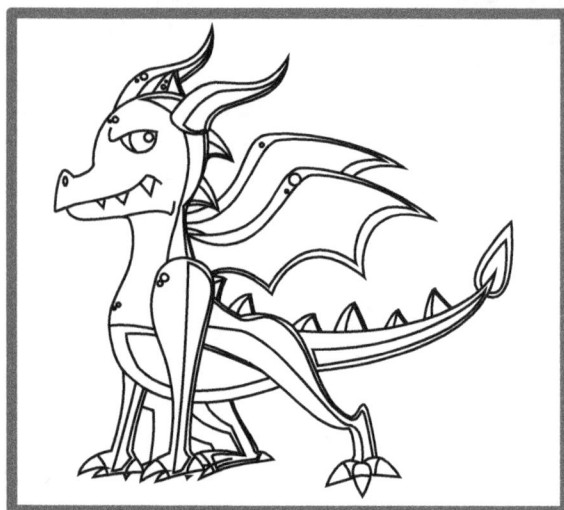

DRAW
THE
IMAGE

This is a Bleed Through Page If You Are Using a Coloring Marker or Pen!
Find Other Great Titles By searching for Activibooks For Kids on Your Favorite Book Retailer
Amazon.Com | Barnes & Noble (BN.Com) | Books A Million (BAM.Com)

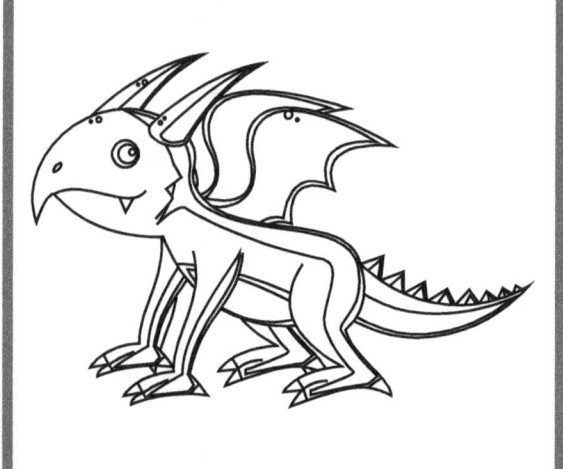

DRAW
THE
IMAGE

This is a Bleed Through Page If You Are Using a Coloring Marker or Pen!
Find Other Great Titles By searching for Activibooks For Kids on Your Favorite Book Retailer
Amazon.Com | Barnes & Noble (BN.Com) | Books A Million (BAM.Com)

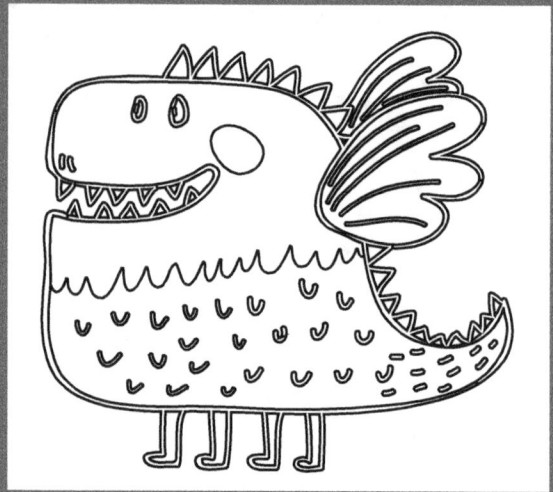

DRAW
THE
IMAGE

This is a Bleed Through Page If You Are Using a Coloring Marker or Pen!
Find Other Great Titles By searching for Activibooks For Kids on Your Favorite Book Retailer
Amazon.Com | Barnes & Noble (BN.Com) | Books A Million (BAM.Com)

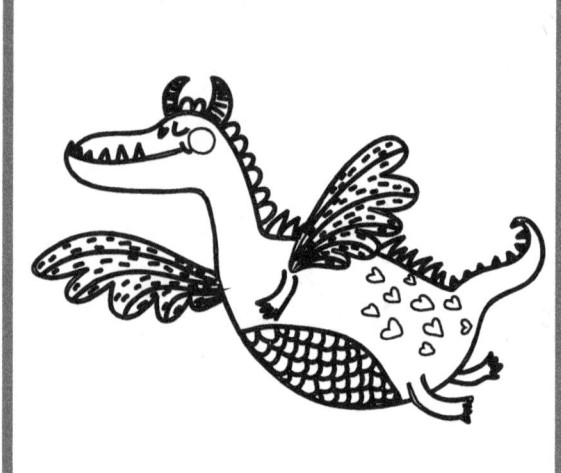

DRAW
THE
IMAGE

This is a Bleed Through Page If You Are Using a Coloring Marker or Pen!
Find Other Great Titles By searching for Activibooks For Kids on Your Favorite Book Retailer
Amazon.Com | Barnes & Noble (BN.Com) | Books A Million (BAM.Com)

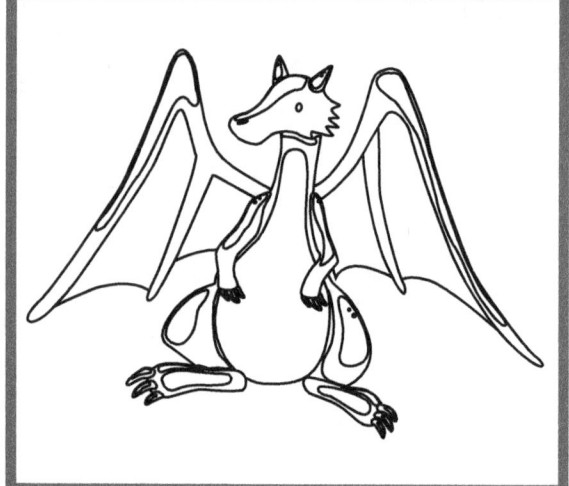

DRAW
THE
IMAGE

This is a Bleed Through Page If You Are Using a Coloring Marker or Pen!
Find Other Great Titles By searching for Activibooks For Kids on Your Favorite Book Retailer
Amazon.Com | Barnes & Noble (BN.Com) | Books A Million (BAM.Com)

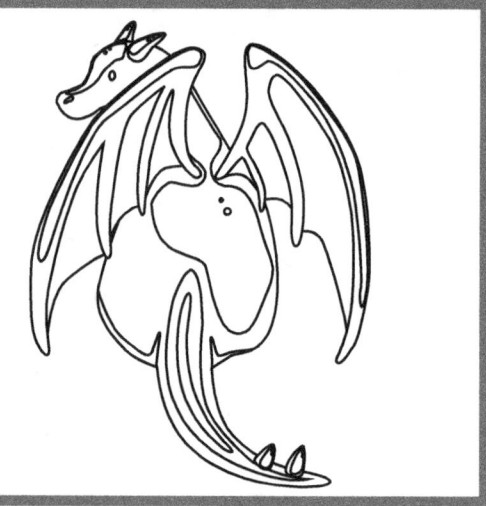

DRAW
THE
IMAGE

This is a Bleed Through Page If You Are Using a Coloring Marker or Pen!
Find Other Great Titles By searching for Activibooks For Kids on Your Favorite Book Retailer
Amazon.Com | Barnes & Noble (BN.Com) | Books A Million (BAM.Com)

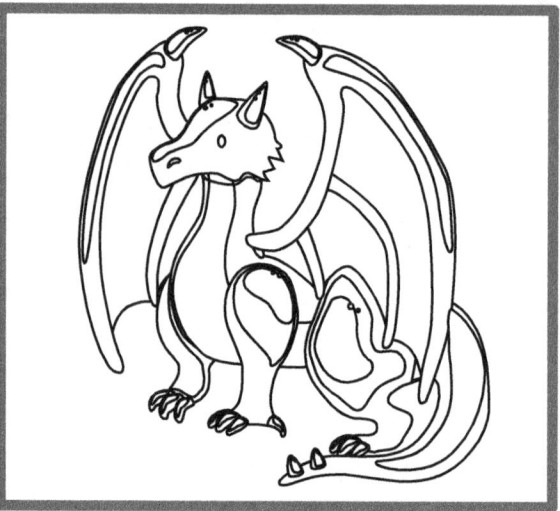

DRAW
THE
IMAGE

This is a Bleed Through Page If You Are Using a Coloring Marker or Pen!
Find Other Great Titles By searching for Activibooks For Kids on Your Favorite Book Retailer
Amazon.Com | Barnes & Noble (BN.Com) | Books A Million (BAM.Com)

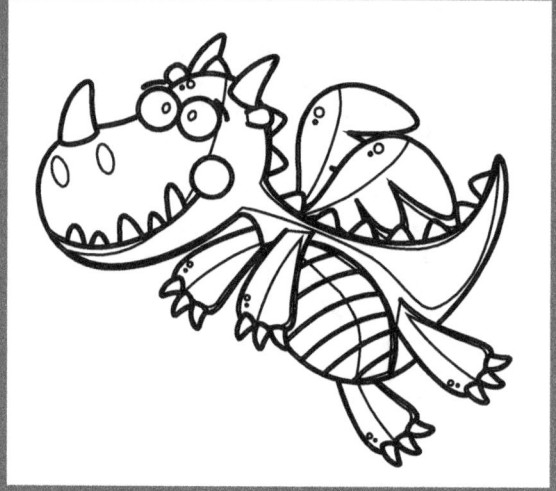

DRAW
THE
IMAGE

This is a Bleed Through Page If You Are Using a Coloring Marker or Pen!
Find Other Great Titles By searching for Activibooks For Kids on Your Favorite Book Retailer
Amazon.Com | Barnes & Noble (BN.Com) | Books A Million (BAM.Com)

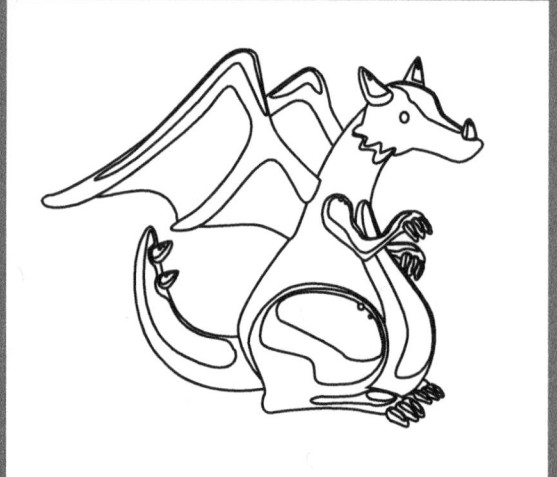

DRAW
THE
IMAGE

This is a Bleed Through Page If You Are Using a Coloring Marker or Pen!
Find Other Great Titles By searching for Activibooks For Kids on Your Favorite Book Retailer
Amazon.Com | Barnes & Noble (BN.Com) | Books A Million (BAM.Com)

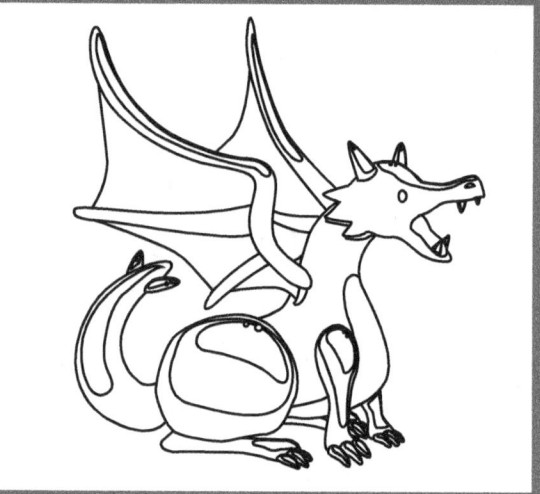

DRAW
THE
IMAGE

This is a Bleed Through Page If You Are Using a Coloring Marker or Pen!
Find Other Great Titles By searching for Activibooks For Kids on Your Favorite Book Retailer
Amazon.Com | Barnes & Noble (BN.Com) | Books A Million (BAM.Com)

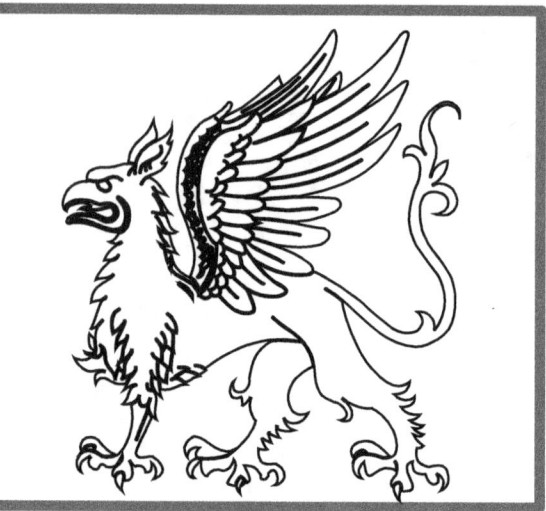

DRAW
THE
IMAGE

This is a Bleed Through Page If You Are Using a Coloring Marker or Pen!
Find Other Great Titles By searching for Activibooks For Kids on Your Favorite Book Retailer
Amazon.Com | Barnes & Noble (BN.Com) | Books A Million (BAM.Com)

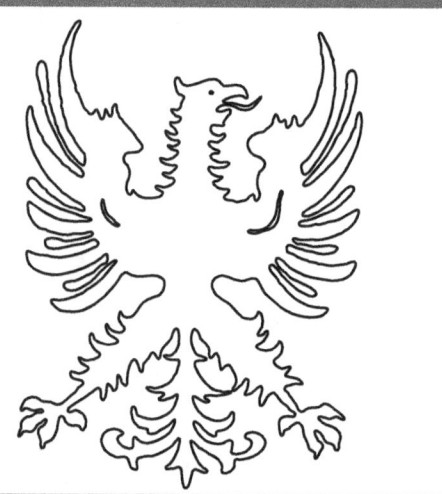

DRAW
THE
IMAGE

This is a Bleed Through Page If You Are Using a Coloring Marker or Pen!
Find Other Great Titles By searching for Activibooks For Kids on Your Favorite Book Retailer
Amazon.Com | Barnes & Noble (BN.Com) | Books A Million (BAM.Com)

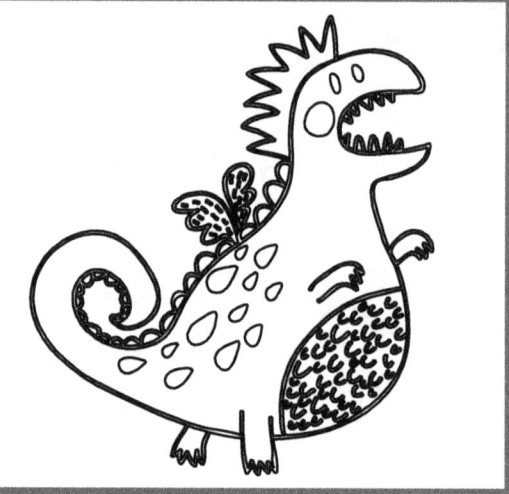

DRAW
THE
IMAGE

This is a Bleed Through Page If You Are Using a Coloring Marker or Pen!
Find Other Great Titles By searching for Activibooks For Kids on Your Favorite Book Retailer
Amazon.Com | Barnes & Noble (BN.Com) | Books A Million (BAM.Com)

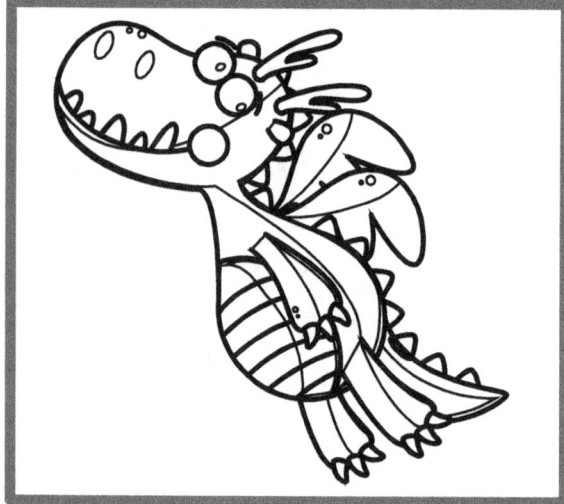

DRAW
THE
IMAGE

This is a Bleed Through Page If You Are Using a Coloring Marker or Pen!
Find Other Great Titles By searching for Activibooks For Kids on Your Favorite Book Retailer
Amazon.Com | Barnes & Noble (BN.Com) | Books A Million (BAM.Com)

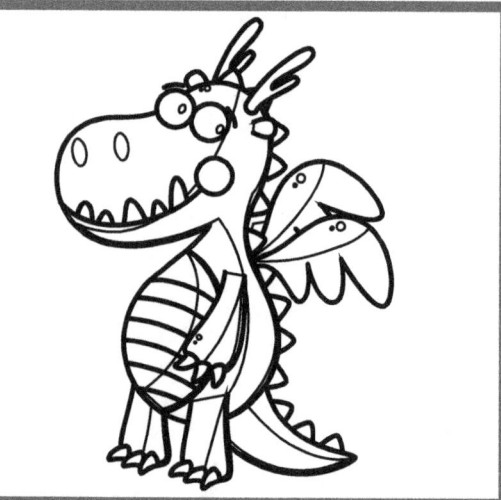

DRAW
THE
IMAGE

This is a Bleed Through Page If You Are Using a Coloring Marker or Pen!
Find Other Great Titles By searching for Activibooks For Kids on Your Favorite Book Retailer
Amazon.Com | Barnes & Noble (BN.Com) | Books A Million (BAM.Com)

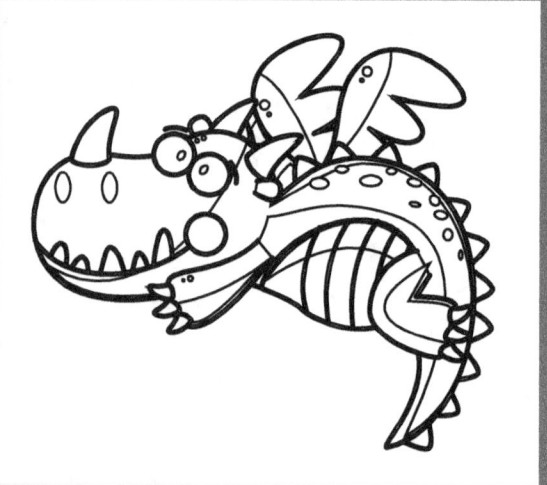

DRAW
THE
IMAGE

This is a Bleed Through Page If You Are Using a Coloring Marker or Pen!
Find Other Great Titles By searching for Activibooks For Kids on Your Favorite Book Retailer
Amazon.Com | Barnes & Noble (BN.Com) | Books A Million (BAM.Com)

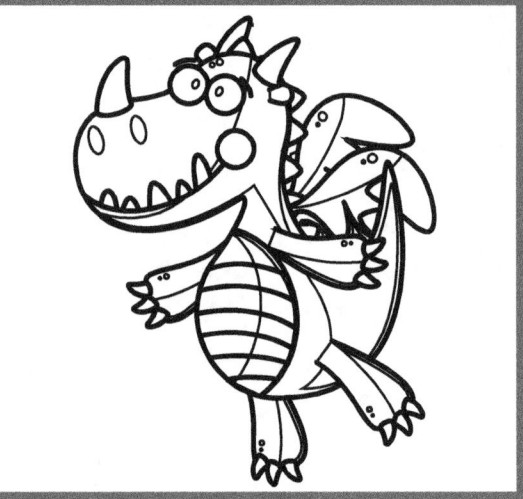

DRAW
THE
IMAGE

This is a Bleed Through Page If You Are Using a Coloring Marker or Pen!
Find Other Great Titles By searching for Activibooks For Kids on Your Favorite Book Retailer
Amazon.Com | Barnes & Noble (BN.Com) | Books A Million (BAM.Com)

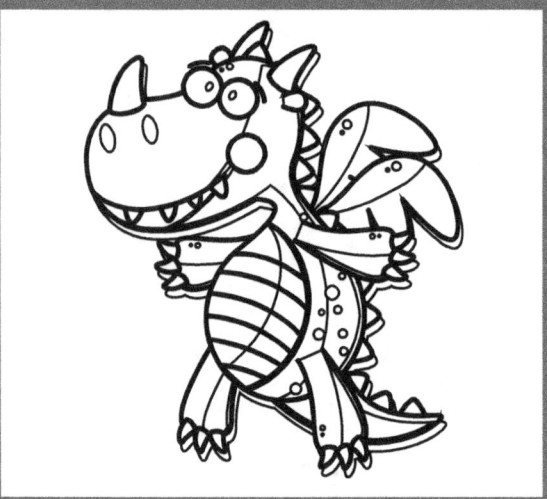

DRAW
THE
IMAGE

This is a Bleed Through Page If You Are Using a Coloring Marker or Pen!
Find Other Great Titles By searching for Activibooks For Kids on Your Favorite Book Retailer
Amazon.Com | Barnes & Noble (BN.Com) | Books A Million (BAM.Com)

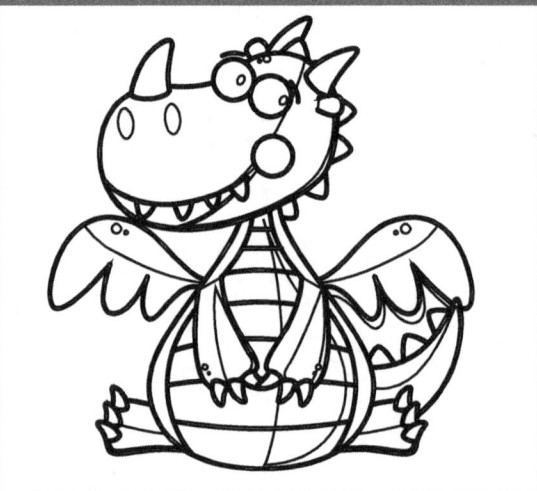

DRAW
THE
IMAGE

This is a Bleed Through Page If You Are Using a Coloring Marker or Pen!
Find Other Great Titles By searching for Activibooks For Kids on Your Favorite Book Retailer
Amazon.Com | Barnes & Noble (BN.Com) | Books A Million (BAM.Com)

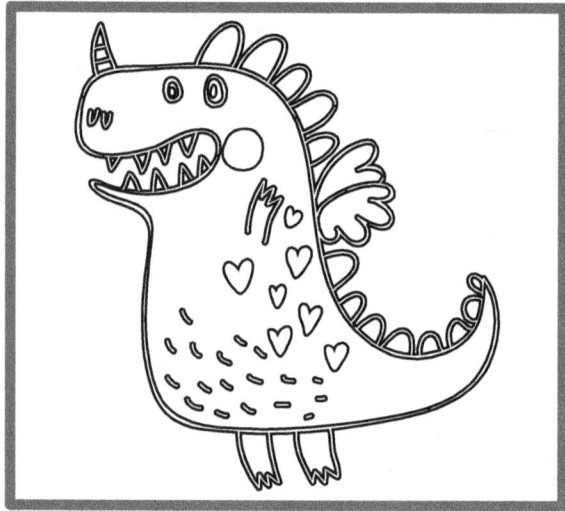

DRAW
THE
IMAGE

This is a Bleed Through Page If You Are Using a Coloring Marker or Pen!
Find Other Great Titles By searching for Activibooks For Kids on Your Favorite Book Retailer
Amazon.Com | Barnes & Noble (BN.Com) | Books A Million (BAM.Com)

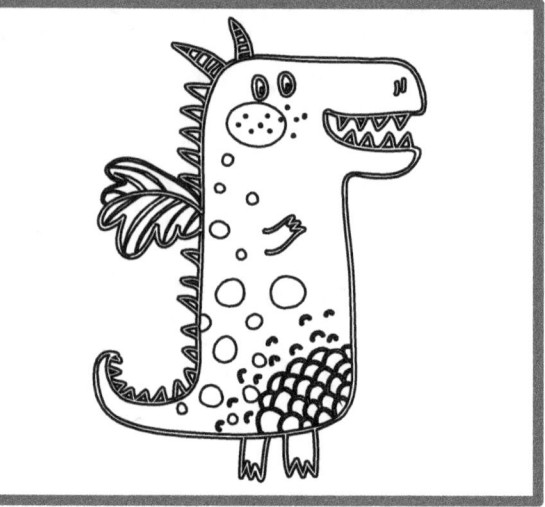

DRAW
THE
IMAGE

This is a Bleed Through Page If You Are Using a Coloring Marker or Pen!
Find Other Great Titles By searching for Activibooks For Kids on Your Favorite Book Retailer
Amazon.Com | Barnes & Noble (BN.Com) | Books A Million (BAM.Com)

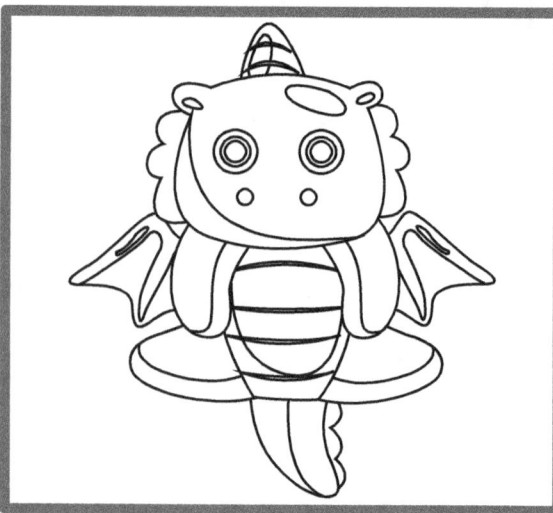

DRAW
THE
IMAGE

This is a Bleed Through Page If You Are Using a Coloring Marker or Pen!
Find Other Great Titles By searching for Activibooks For Kids on Your Favorite Book Retailer
Amazon.Com | Barnes & Noble (BN.Com) | Books A Million (BAM.Com)

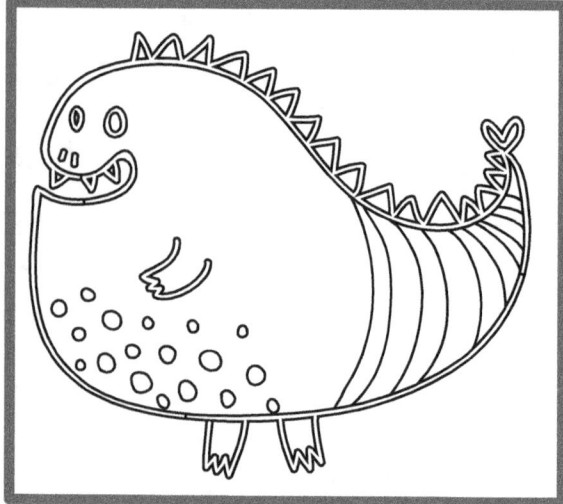

DRAW
THE
IMAGE

This is a Bleed Through Page If You Are Using a Coloring Marker or Pen!
Find Other Great Titles By searching for Activibooks For Kids on Your Favorite Book Retailer
Amazon.Com | Barnes & Noble (BN.Com) | Books A Million (BAM.Com)

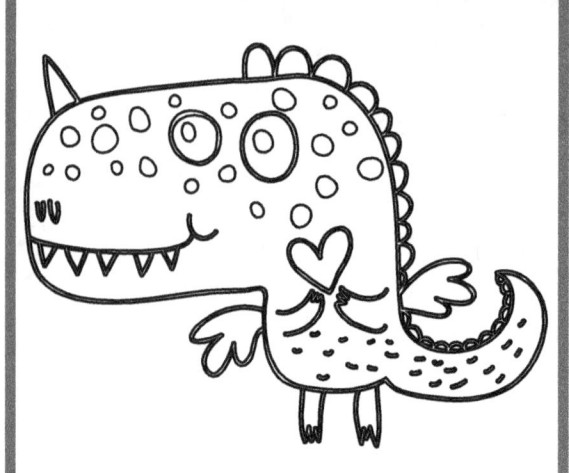

DRAW
THE
IMAGE

This is a Bleed Through Page If You Are Using a Coloring Marker or Pen!
Find Other Great Titles By searching for Activibooks For Kids on Your Favorite Book Retailer
Amazon.Com | Barnes & Noble (BN.Com) | Books A Million (BAM.Com)

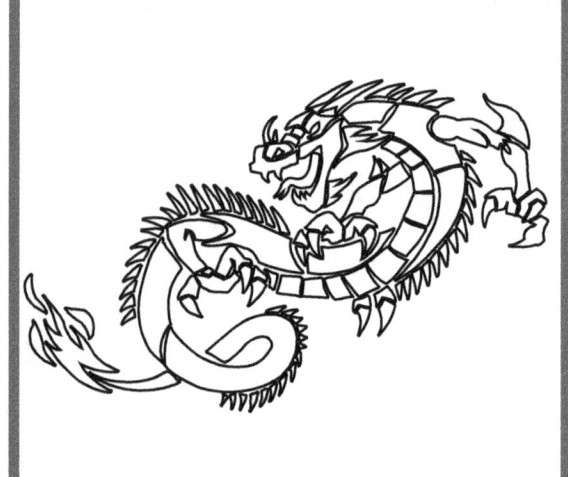

DRAW
THE
IMAGE

This is a Bleed Through Page If You Are Using a Coloring Marker or Pen!
Find Other Great Titles By searching for Activibooks For Kids on Your Favorite Book Retailer
Amazon.Com | Barnes & Noble (BN.Com) | Books A Million (BAM.Com)

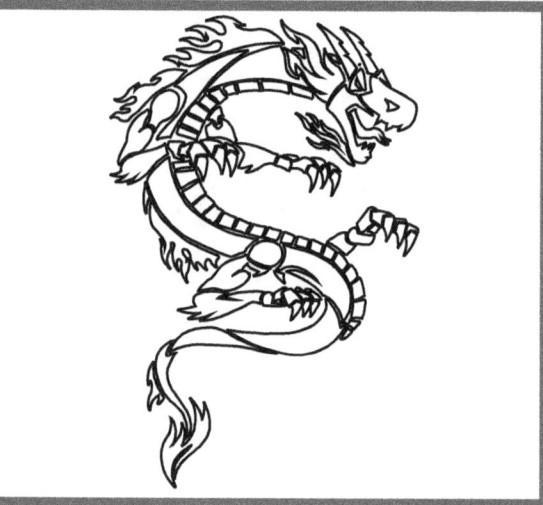

DRAW
THE
IMAGE

This is a Bleed Through Page If You Are Using a Coloring Marker or Pen!
Find Other Great Titles By searching for Activibooks For Kids on Your Favorite Book Retailer
Amazon.Com | Barnes & Noble (BN.Com) | Books A Million (BAM.Com)

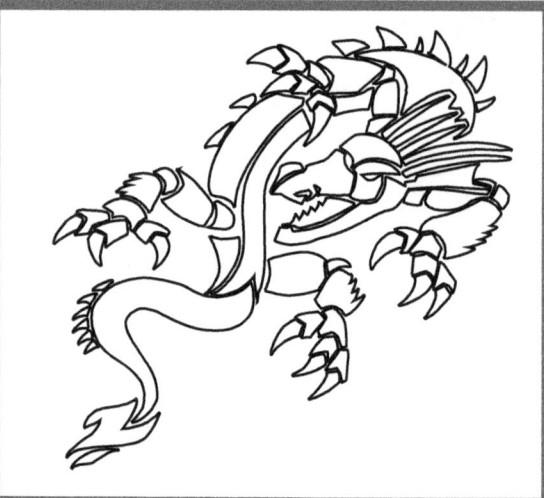

DRAW
THE
IMAGE

This is a Bleed Through Page If You Are Using a Coloring Marker or Pen!
Find Other Great Titles By searching for Activibooks For Kids on Your Favorite Book Retailer
Amazon.Com | Barnes & Noble (BN.Com) | Books A Million (BAM.Com)

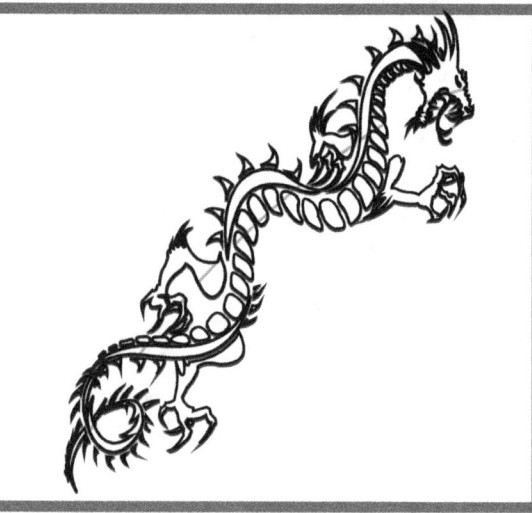

DRAW
THE
IMAGE

This is a Bleed Through Page If You Are Using a Coloring Marker or Pen!
Find Other Great Titles By searching for Activibooks For Kids on Your Favorite Book Retailer
Amazon.Com | Barnes & Noble (BN.Com) | Books A Million (BAM.Com)

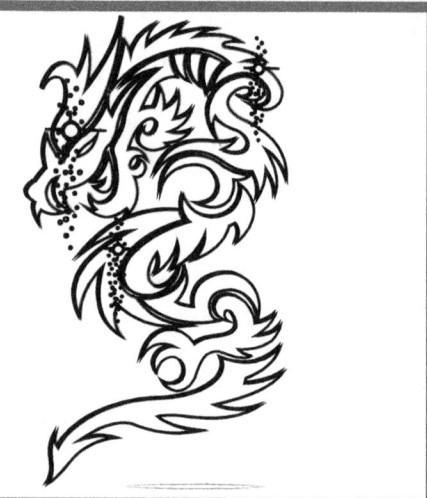

DRAW
THE
IMAGE

This is a Bleed Through Page If You Are Using a Coloring Marker or Pen!
Find Other Great Titles By searching for Activibooks For Kids on Your Favorite Book Retailer
Amazon.Com | Barnes & Noble (BN.Com) | Books A Million (BAM.Com)

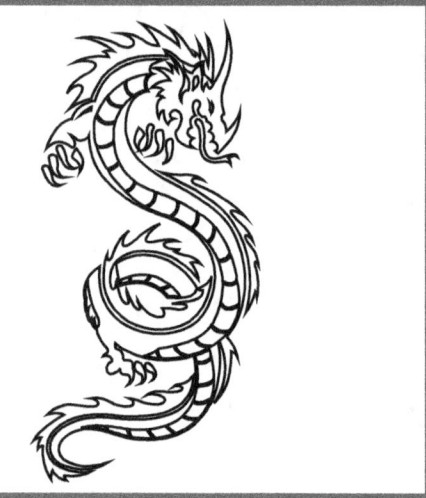

DRAW
THE
IMAGE

This is a Bleed Through Page If You Are Using a Coloring Marker or Pen!
Find Other Great Titles By searching for Activibooks For Kids on Your Favorite Book Retailer
Amazon.Com | Barnes & Noble (BN.Com) | Books A Million (BAM.Com)

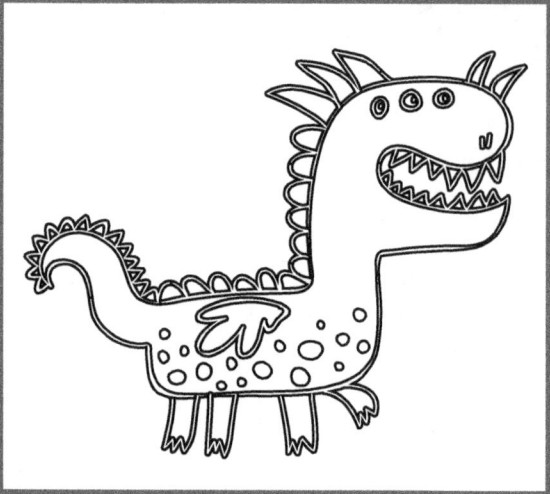

DRAW
THE
IMAGE

This is a Bleed Through Page If You Are Using a Coloring Marker or Pen!
Find Other Great Titles By searching for Activibooks For Kids on Your Favorite Book Retailer
Amazon.Com | Barnes & Noble (BN.Com) | Books A Million (BAM.Com)

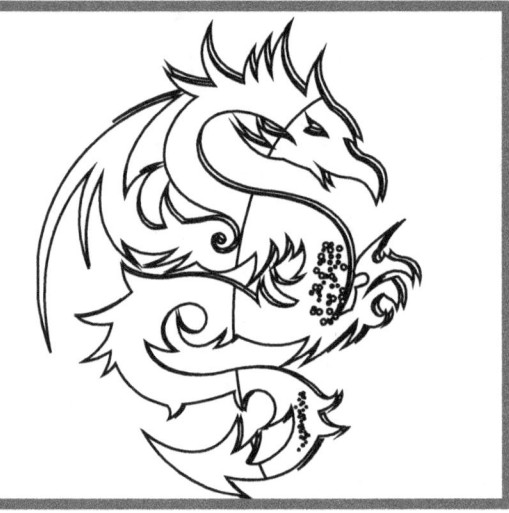

DRAW
THE
IMAGE

This is a Bleed Through Page If You Are Using a Coloring Marker or Pen!
Find Other Great Titles By searching for Activibooks For Kids on Your Favorite Book Retailer
Amazon.Com | Barnes & Noble (BN.Com) | Books A Million (BAM.Com)

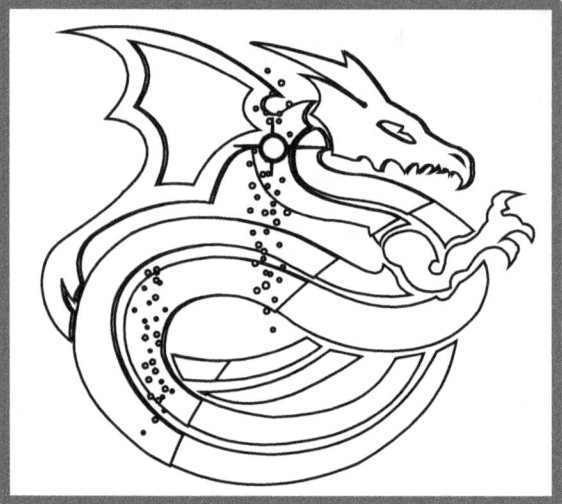

DRAW
THE
IMAGE

This is a Bleed Through Page If You Are Using a Coloring Marker or Pen!
Find Other Great Titles By searching for Activibooks For Kids on Your Favorite Book Retailer
Amazon.Com | Barnes & Noble (BN.Com) | Books A Million (BAM.Com)

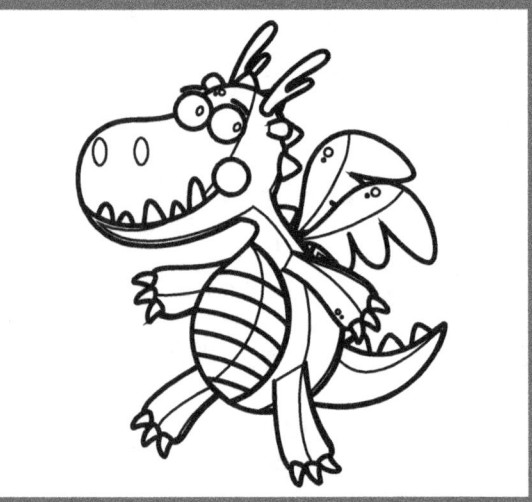

DRAW
THE
IMAGE

This is a Bleed Through Page If You Are Using a Coloring Marker or Pen!
Find Other Great Titles By searching for Activibooks For Kids on Your Favorite Book Retailer
Amazon.Com | Barnes & Noble (BN.Com) | Books A Million (BAM.Com)

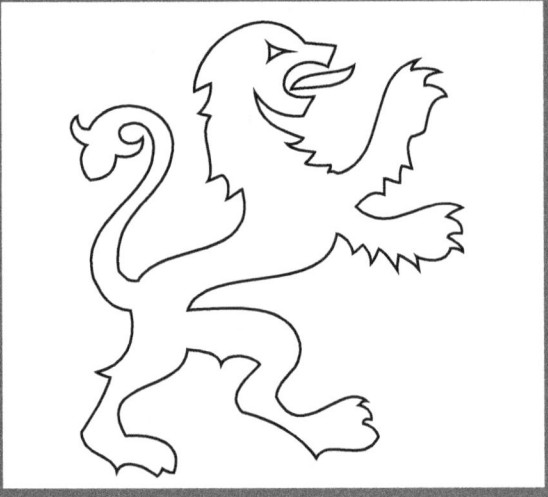

DRAW
THE
IMAGE

This is a Bleed Through Page If You Are Using a Coloring Marker or Pen!
Find Other Great Titles By searching for Activibooks For Kids on Your Favorite Book Retailer
Amazon.Com | Barnes & Noble (BN.Com) | Books A Million (BAM.Com)

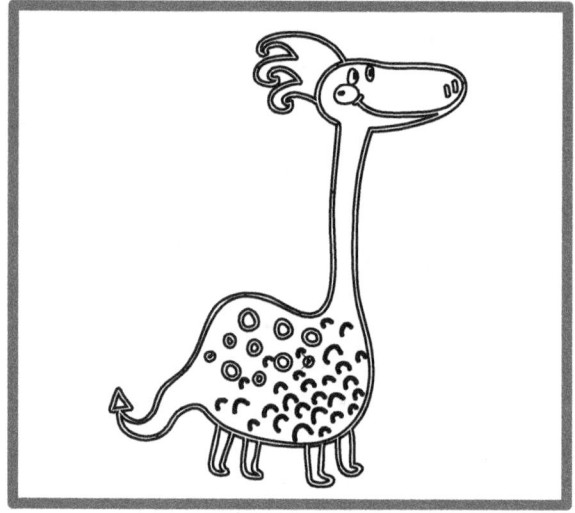

DRAW
THE
IMAGE

This is a Bleed Through Page If You Are Using a Coloring Marker or Pen!
Find Other Great Titles By searching for Activibooks For Kids on Your Favorite Book Retailer
Amazon.Com | Barnes & Noble (BN.Com) | Books A Million (BAM.Com)

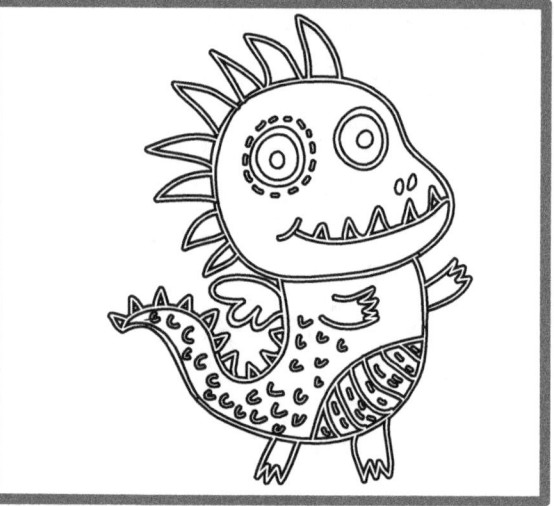

DRAW
THE
IMAGE

This is a Bleed Through Page If You Are Using a Coloring Marker or Pen!
Find Other Great Titles By searching for Activibooks For Kids on Your Favorite Book Retailer
Amazon.Com | Barnes & Noble (BN.Com) | Books A Million (BAM.Com)

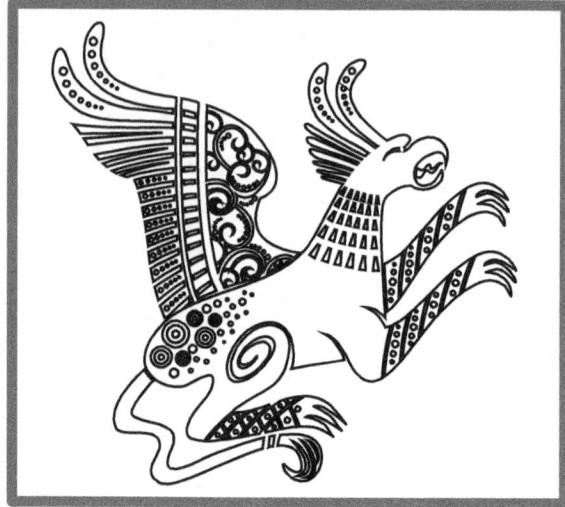

DRAW
THE
IMAGE

This is a Bleed Through Page If You Are Using a Coloring Marker or Pen!
Find Other Great Titles By searching for Activibooks For Kids on Your Favorite Book Retailer
Amazon.Com | Barnes & Noble (BN.Com) | Books A Million (BAM.Com)

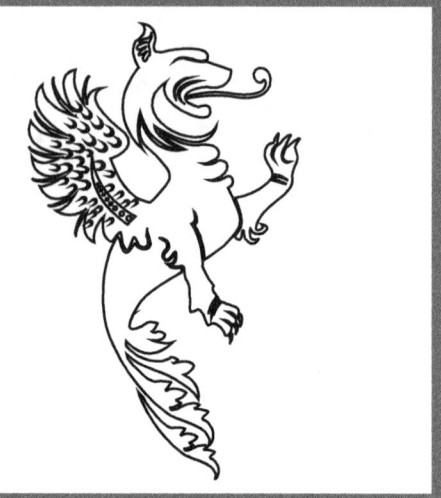

DRAW
THE
IMAGE

This is a Bleed Through Page If You Are Using a Coloring Marker or Pen!
Find Other Great Titles By searching for Activibooks For Kids on Your Favorite Book Retailer
Amazon.Com | Barnes & Noble (BN.Com) | Books A Million (BAM.Com)

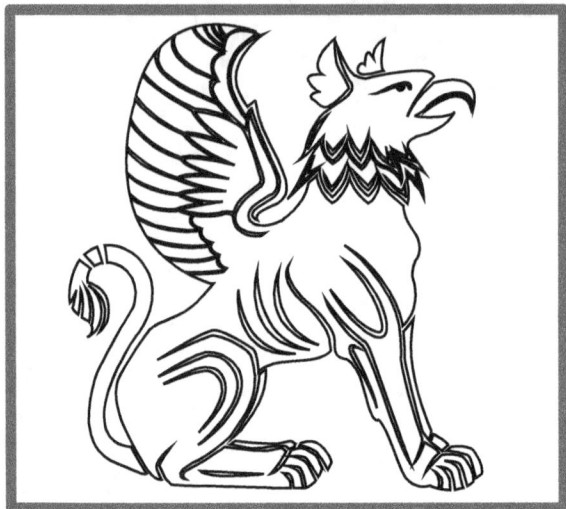

DRAW
THE
IMAGE

This is a Bleed Through Page If You Are Using a Coloring Marker or Pen!
Find Other Great Titles By searching for Activibooks For Kids on Your Favorite Book Retailer
Amazon.Com | Barnes & Noble (BN.Com) | Books A Million (BAM.Com)

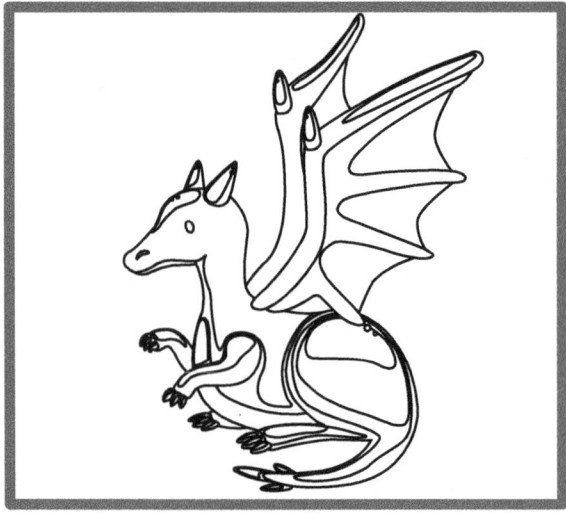

DRAW
THE
IMAGE

This is a Bleed Through Page If You Are Using a Coloring Marker or Pen!
Find Other Great Titles By searching for Activibooks For Kids on Your Favorite Book Retailer
Amazon.Com | Barnes & Noble (BN.Com) | Books A Million (BAM.Com)

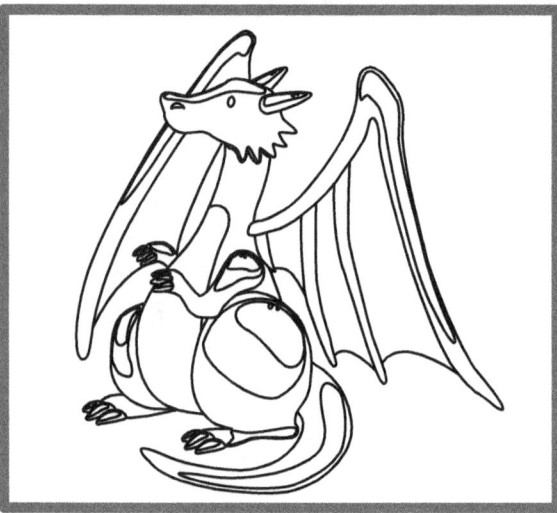

DRAW
THE
IMAGE

This is a Bleed Through Page If You Are Using a Coloring Marker or Pen!
Find Other Great Titles By searching for Activibooks For Kids on Your Favorite Book Retailer
Amazon.Com | Barnes & Noble (BN.Com) | Books A Million (BAM.Com)

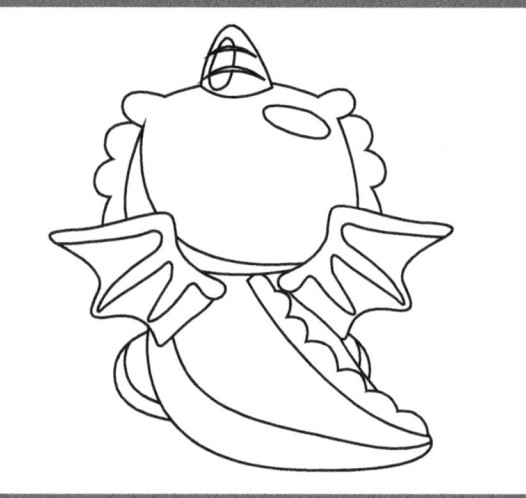

DRAW
THE
IMAGE

This is a Bleed Through Page If You Are Using a Coloring Marker or Pen!
Find Other Great Titles By searching for Activibooks For Kids on Your Favorite Book Retailer
Amazon.Com | Barnes & Noble (BN.Com) | Books A Million (BAM.Com)

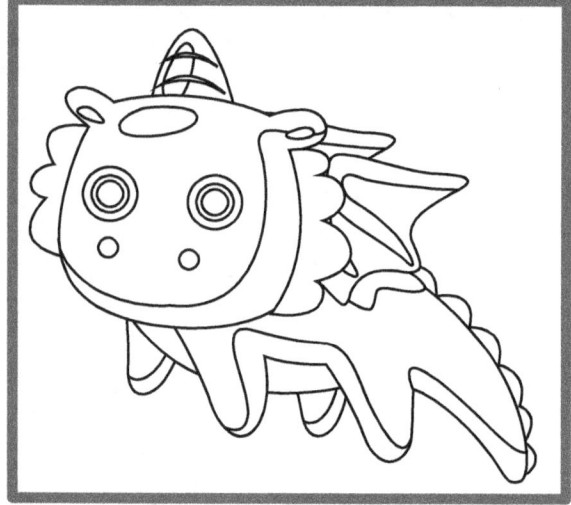

DRAW
THE
IMAGE

This is a Bleed Through Page If You Are Using a Coloring Marker or Pen!
Find Other Great Titles By searching for Activibooks For Kids on Your Favorite Book Retailer
Amazon.Com | Barnes & Noble (BN.Com) | Books A Million (BAM.Com)

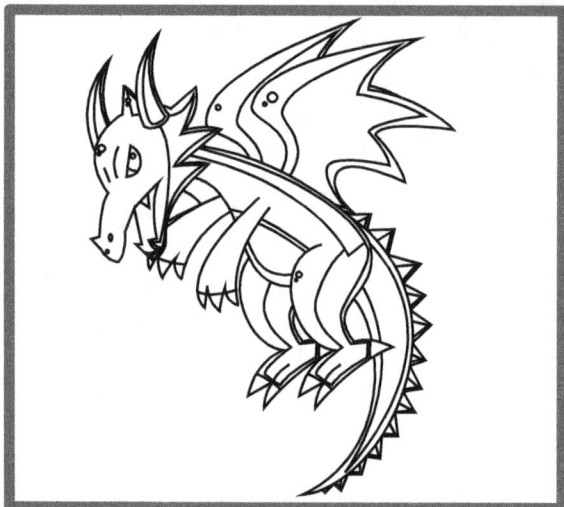

DRAW
THE
IMAGE

This is a Bleed Through Page If You Are Using a Coloring Marker or Pen!
Find Other Great Titles By searching for Activibooks For Kids on Your Favorite Book Retailer
Amazon.Com | Barnes & Noble (BN.Com) | Books A Million (BAM.Com)

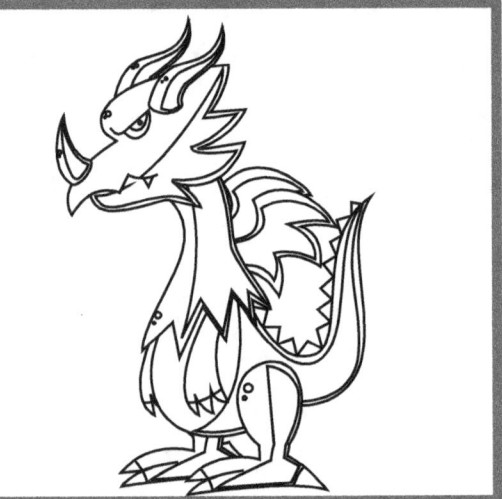

DRAW
THE
IMAGE

This is a Bleed Through Page If You Are Using a Coloring Marker or Pen!
Find Other Great Titles By searching for Activibooks For Kids on Your Favorite Book Retailer
Amazon.Com | Barnes & Noble (BN.Com) | Books A Million (BAM.Com)

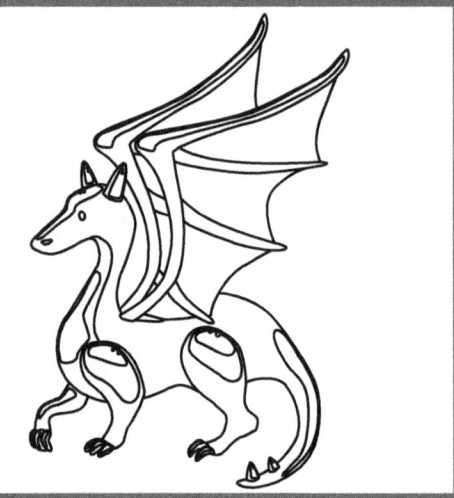

DRAW
THE
IMAGE

This is a Bleed Through Page If You Are Using a Coloring Marker or Pen!
Find Other Great Titles By searching for Activibooks For Kids on Your Favorite Book Retailer
Amazon.Com | Barnes & Noble (BN.Com) | Books A Million (BAM.Com)

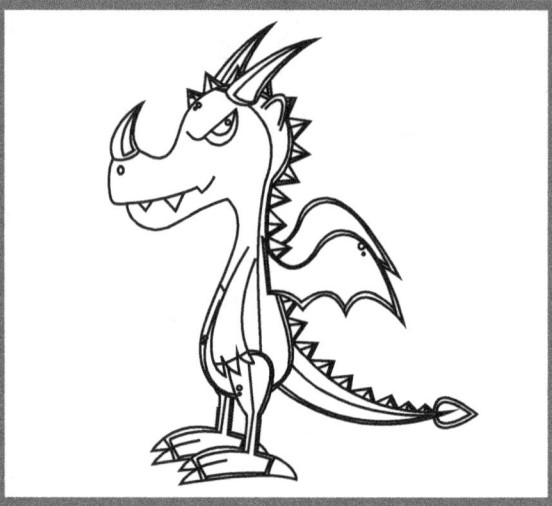

DRAW
THE
IMAGE

This is a Bleed Through Page If You Are Using a Coloring Marker or Pen!
Find Other Great Titles By searching for Activibooks For Kids on Your Favorite Book Retailer
Amazon.Com | Barnes & Noble (BN.Com) | Books A Million (BAM.Com)

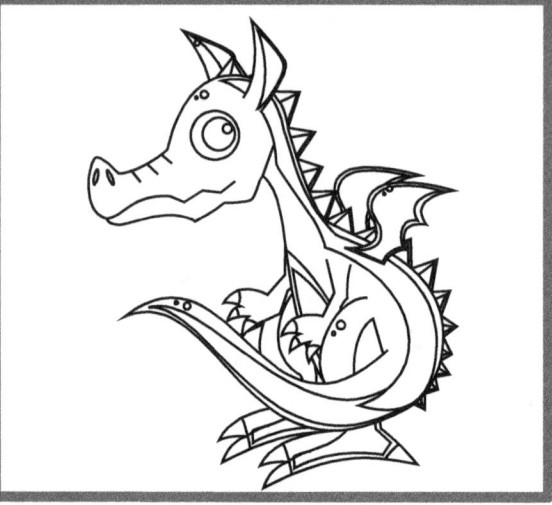

DRAW
THE
IMAGE

This is a Bleed Through Page If You Are Using a Coloring Marker or Pen!
Find Other Great Titles By searching for Activibooks For Kids on Your Favorite Book Retailer
Amazon.Com | Barnes & Noble (BN.Com) | Books A Million (BAM.Com)

www.ingramcontent.com/pod-product-compliance
Lightning Source LLC
Chambersburg PA
CBHW081439220526
45466CB00008B/2449